IDENTITY

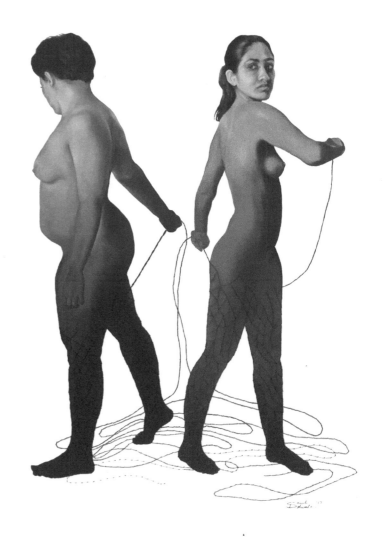

IDENTITY

IDENTITY

Identity Produced and published by Jen Tough Gallery
www.JenTough.gallery
7 Ave Vista Grande #B7-425 | Santa Fe, NM 87508

Image on Cover: Sarah Detweiler, *Collective Unraveling (It Starts With Two)*
www.SarahDetweiler.com

For use and reproduction permissions contact:
www.JenTough.gallery

Copyright 2020 | Printed in the USA
ISBN 978-1-7358631-0-8
First Edition

IDENTITY

Inside

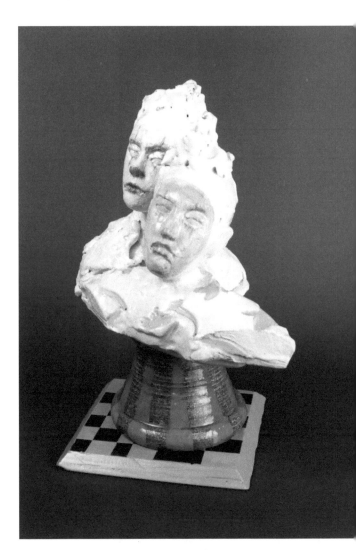

Maryann Steinert-Foley, *Curtain Call*, 2018, ceramic on wood base, 11w x 10h x 8d

Maryann Steinert-Foley
The Personal is Political

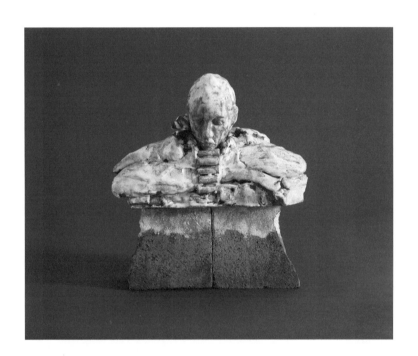

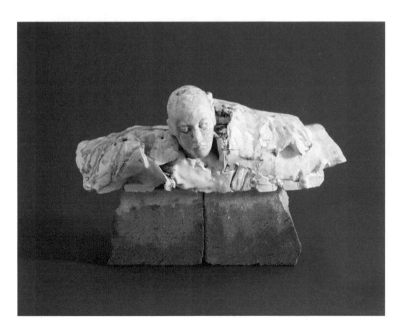

Maryann Steinert-Foley was born in Flushing, New York in 1950. She completed a BA in Art Studio, with honors, at the University of California, Davis in 2011 and received the Departmental Citation for Outstanding Performance from the UC Davis Art Department Faculty. Her interest is mainly in ceramic sculpture but her work also includes paintings and drawings. Clay is her preferred sculptural medium due in no small part to the years she worked in the historically fertile and creative atmosphere of TB-9 – a WWII era temporary building on the UC Davis campus which still serves as a ceramics teaching facility and is widely considered to be the place where, beginning in the mid '60s, Bob Arneson oversaw the elevation of ceramics from craft to fine Art. The TB-9 idea that work ought to show "evidence of the artist's hand" is prominent in Maryann's sculpture.

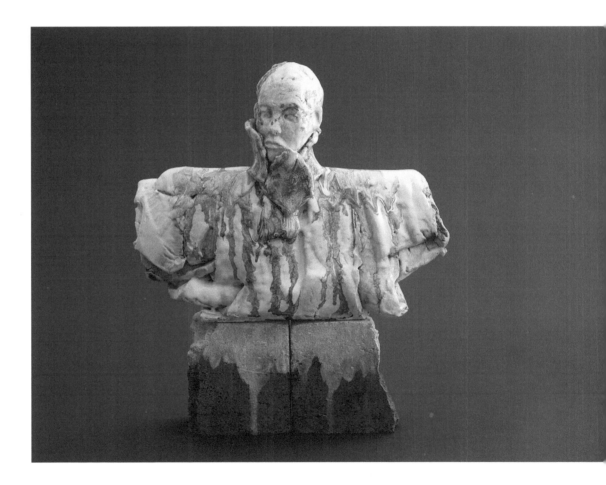

Left: *Justice RBG*, 2018, ceramic sculpture, 14w x 15h x 4d
Name here, 2018, ceramic sculpture, 14w x 15h x 4d

Above: *Forbearance*, 2018, ceramic sculpture, 14w x 15h x 4d

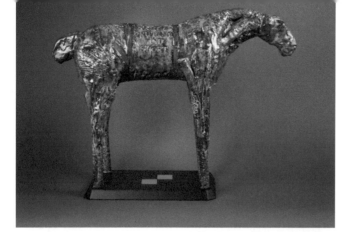

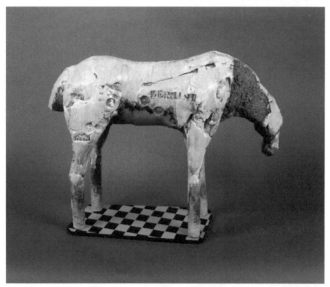

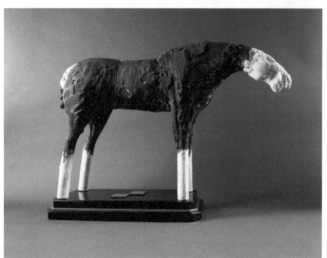

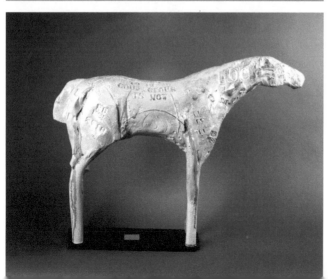

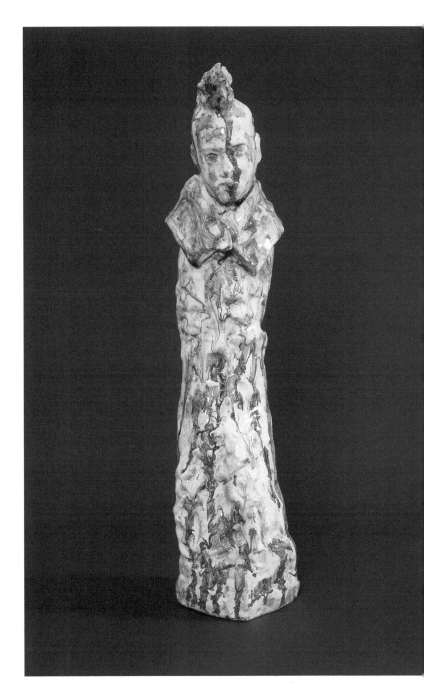

Left, top to bottom:

Toiling in Obscurity 2019
ceramic on wood base
22w x 16h x 6.5d

Horse For My Grandparents
2018 ceramic on wood base
19w x 14h x 7d

Dusk, 2019 ceramic on wood base
26w x 17h x 8d

AOC 2019 ceramic on wood base
23.5w x 17h x 4.75d

Prudence, 2018, ceramic on wood base, 7w x 21h x 7d

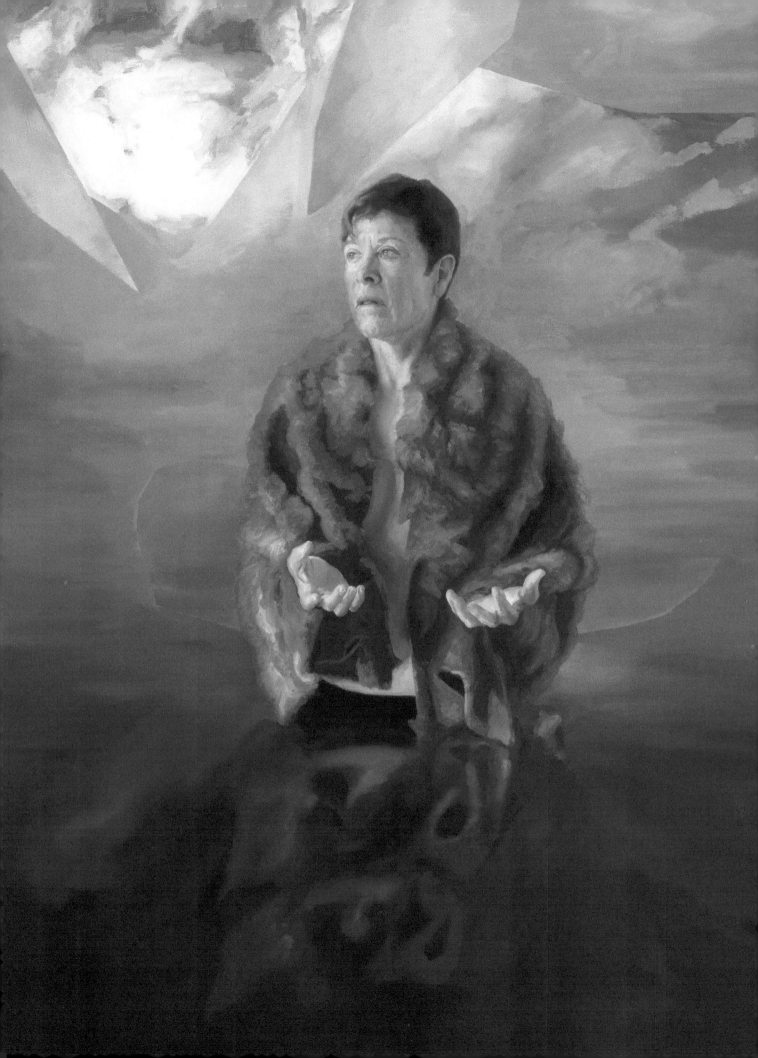

Tamera Avery
Hell's Valley

Tamera Avery is an artist whose uncompromising paintings project and re-contextualize her personal fears and social concerns. By including herself and her children as subjects—often in dreamlike and evocative contexts—Avery makes works that are both relatable and paradoxically tender. Because Avery's technique is grounded in the tradition of Realism, the multi-faceted narratives she paints have a bracing, hallucinatory clarity. The end result of this approach is a flow of brave and confrontational images that demonstrate the artist's commitment to artistic fearlessness.

Although Avery has painted her entire life, she began her professional life as a businesswoman before devoting herself entirely to art in 2001. By studying part-time at a variety of schools—including UC Berkeley and the San Francisco Art Institute—Avery developed her skills over time. She also looked hard at modern and contemporary art and was especially inspired by the works of Francis Bacon and Jenny Saville. In Bacon's work Avery glimpsed an admirable fearlessness while Saville offered the model of a complete and uncompromising approach to depicting the human figure. By 2013 Avery had taken her own work to the point that she felt ready to exhibit in public.

Avery's exhibition Date With the Devil, which appeared at the Napa Valley Museum in the fall of 2013, featured a painting in which the artist's son and daughter served as models and thematic stand-ins. Avery's seven-foot wide canvas 12/14 depicts her son covering his mouth with his hands as his sister rests her head on his shoulders. The painting was made in response to the Sandy Hook shootings, which had occurred the year before on 12/14. The painting's title is the only direct and specific indication of what its subjects are responding to. The setting of the painting, a grove of trees, adds a certain ambiguity. Although Avery is always careful to let her viewers respond to her works in their own way, the canvas carries the necessary implication that the painter's children are contemplating disturbing events.

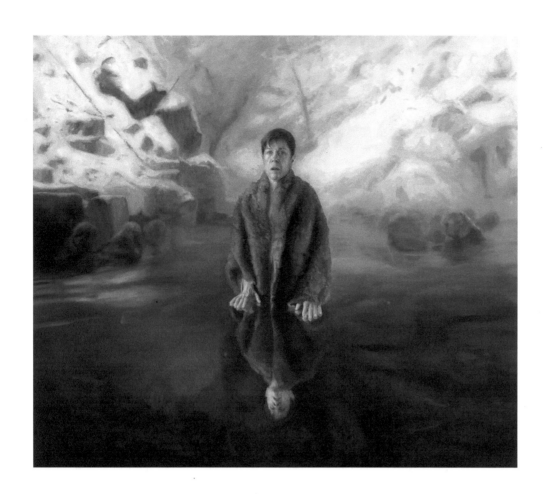

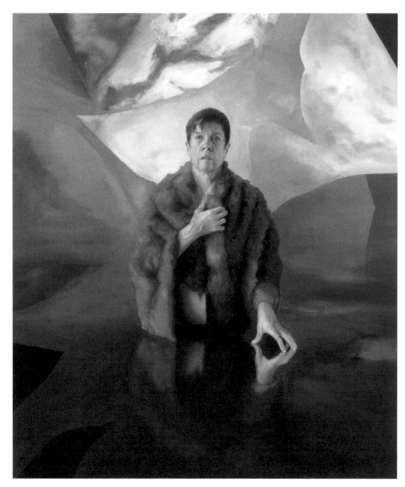

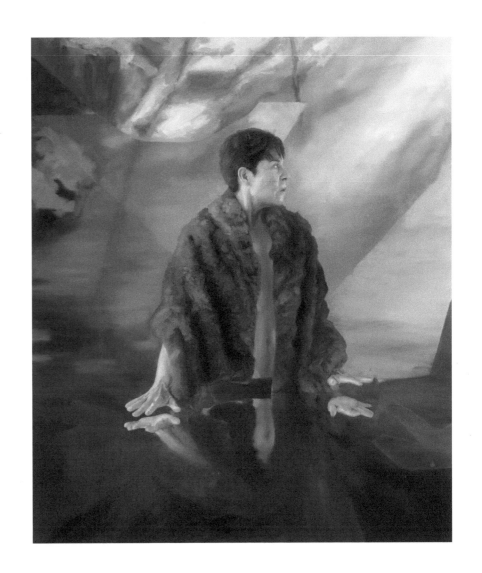

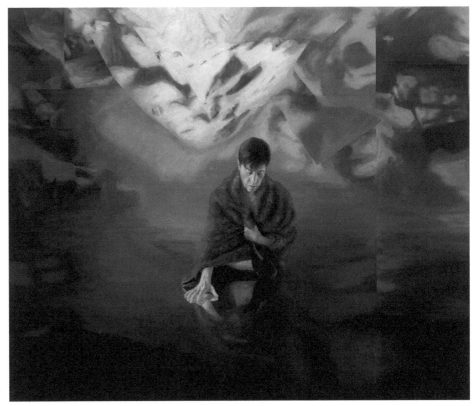

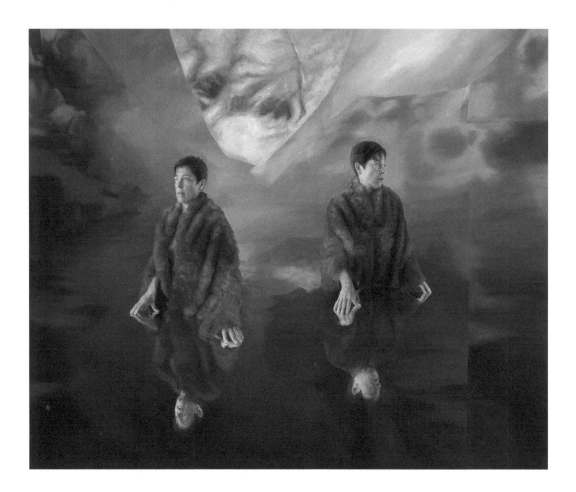

Another painting in the same series—Sitting in for Malala—was made in response to international terrorism. It was inspired by the story of Malala Yousafzai, a Pakistani activist who survived an assassination attempt by a Taliban gunman in 2012 and went on to win a Nobel Peace Prize. As with 12/14, the presence of her children is Avery's way of endowing events taken from the news with immediacy by bringing them as close as possible. "I have to care about what I am doing," Avery comments.

By personalizing her allegories, Avery empowers herself to care about her process in a way that allows her to devote herself to them for the many hours and months they require. The Curtain Paintings that Avery worked on between 2012 and 2015 lacked the direct references to news events that charged her earlier work while continuing the empathetic explorations of her children as subjects. These works, with their psychologically astute attention to the children's gazes and poses, show Avery deepening her ability to suggest interchanges between artist and sitter. By introducing masks, draperies and other headgear in her next series—Off the

Rails— Avery challenged herself to say more with theatrical and contrived settings, often based in collage. They are Avery's darkest and most ambiguous works, challenging viewers to "take what they need" from their implied narratives and allegorical suggestions.

Avery's Hell's Valley paintings are deeply personal works rooted in self-portraiture. They respond to the death of her father and to their tough relationship. "We re-connected before his death," Avery explains, "and attempted to make peace. As we did this it I had to recognize that many things I had once held to be true were false." The settings for this series include glimpses of Japanese snow monkeys, who the artist had been incorrectly told were a matriarchal species. The series is set in a cold, semi-abstract world of snow that offers little possibility of comfort.

As a metaphor, the surrounding landscapes suggest the confusion and desolation that women can feel when their "usefulness" fades in middle age. Appearing once—and sometimes twice—Avery wears a fur cape that both protects and reveals. Although

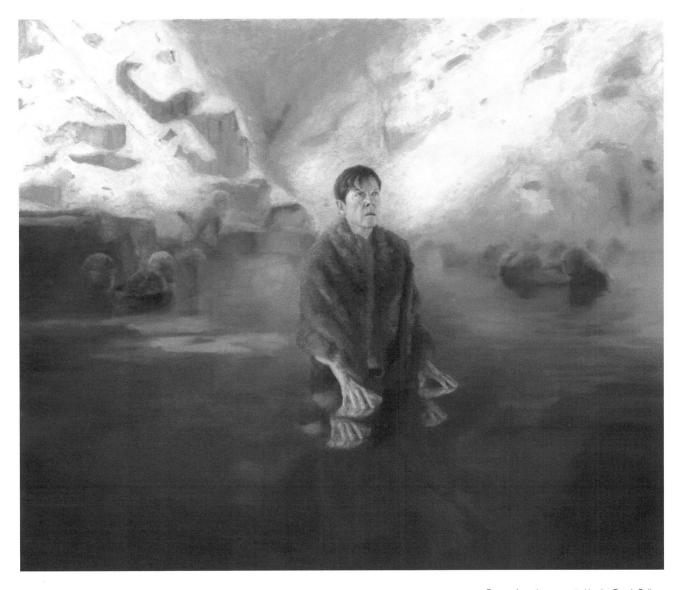

Tamera Avery is represented by Jen Tough Gallery.
She lives and works in San Francisco.
Learn more: www.TameraAvery.com

the paintings are very clear in their style, the meanings they generate are left unresolved. In that lack of emotional clarity there are possibilities and Avery's themes are left open for other women to relate to. Her job has to bring a tough set of uncertain emotions forward and let them resonate.

What Avery seems to be discovering is that she can tell stories in a way that can gain the interest and respect of her viewers. Once that respect is gained a dialog is created and the questions will begin to flow. "What is going on here?" and "What should I be feeling?" are two that often leap out. With more inspection, there are bound to be many, many more. Each of Tamera Avery's paintings—as "complete" as it might appear at first—is just a beginning.

—**John Seed,** 2019

IDENTITY

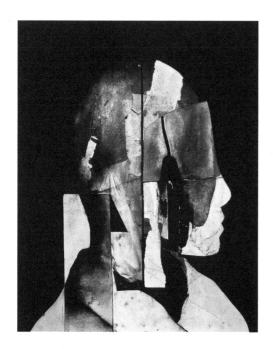

Paul Cristina *Abstract Portrait Study no.2,* charcoal, acrylic and collage on wood panel, 14 x 11 in, 2018 | www.paulcristina.com

Natani Notah *Inner Child,* Leather scraps, jean fabric, seed beads, thread, acrylics, faux fur, artificial sinew, and plastic corn pellets. 16 in x 6 in x 4 in. 2019 | www.nataninotah.com

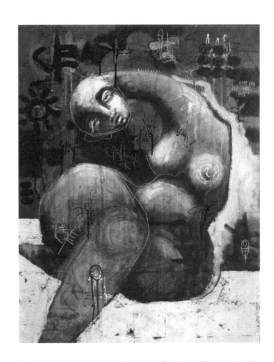

Katie O'Sullivan *She Always Seemed an Outsider of Sorts*, Acrylic, Ink, and 24 karat gold leaf on canvas, 24x30, 2018
www.katieostudios.com

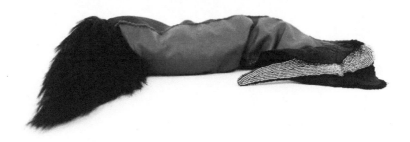

Natani Notah *Dignity,* Leather scraps, seed beads, thread, acrylics, faux fur, artificial sinew, and plastic corn pellets. 23 in x 6 in x 3 in. 2019 | www.nataninotah.com

Tom Owen, *Friends for An Anxious Boy of 14,*
6" x 4", waterborne enamel, wax pastel, and
archival ink jet photograph on paper 2019
www.tomowenfineart.com

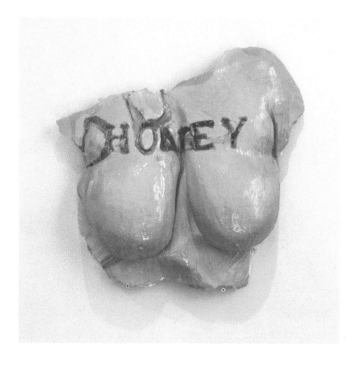

Emily Wilker, *Honey,* Plaster, Flashe Acrylic, Envirotex, Approx. 14" by 18", *2019*
www.emilywilker.com

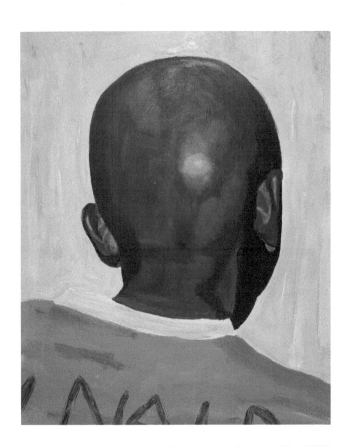

Jonathan Parker, *2 of 4*, Acrylic on wood, 12" x 10", 2020

www.jonathanparker.com

Jenifer Kent, *Migration*, ink on panel, 30" x 30" x 2", 2020 | www.jeniferkent.com

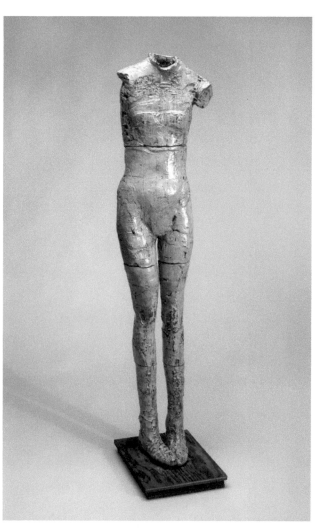

Maryann Steinert-Foley, *Blue*, ceramic, 68" x 14", 2018

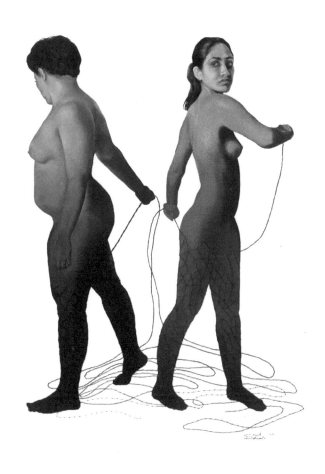

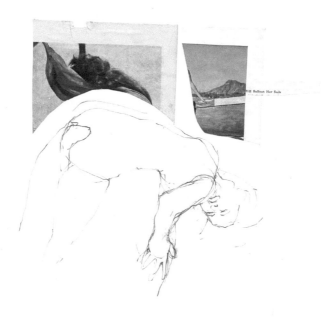

Lita Kenyon, *Will Balloon Her Sails,* Mixed Media Collage, 17" x 14", 2018 I www.litakenyon.art

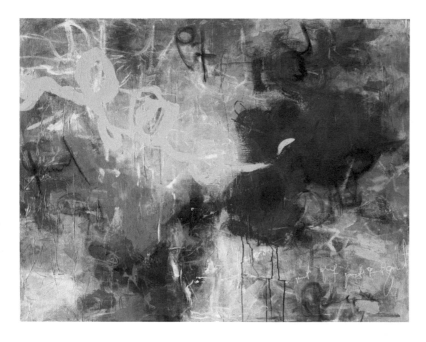

Kelly Marshall, *Quiet,* Mixed Media on Canvas, 48" x 36" x 1.5", 2020 I www.kellymarshallfineart.com

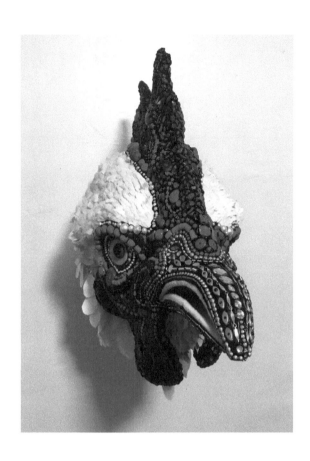

Shannon Freshwater *Chicken Woman*, Mixed media 16"x22"x20" 2019 I www.shannonfreshwater.com

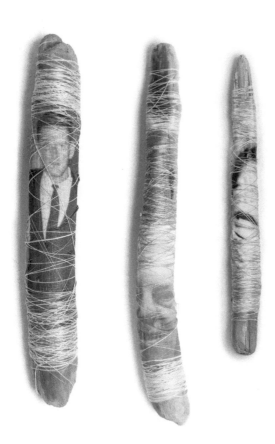

Liz Steketee, *Ghost Sticks, Dad & Innocence 1,* Wood, photo on fabric, wax, string, dimensions
vary I www.lizsteketee.com

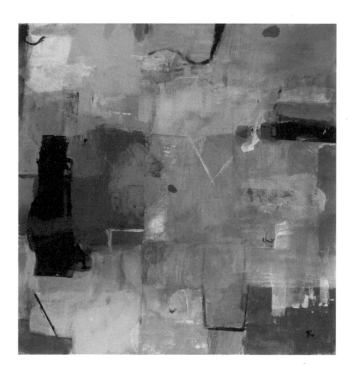

(above) **Judy Levit,** *Mirror,* Acrylic on wood panel, 12 x 12, 2020 I www.judylevit.com

(right) **Liz Steketee,** *Self Portrait,* photo printed on fabric, thread, wax, approx 6 x 9", 2019
www.lizsteketee.com

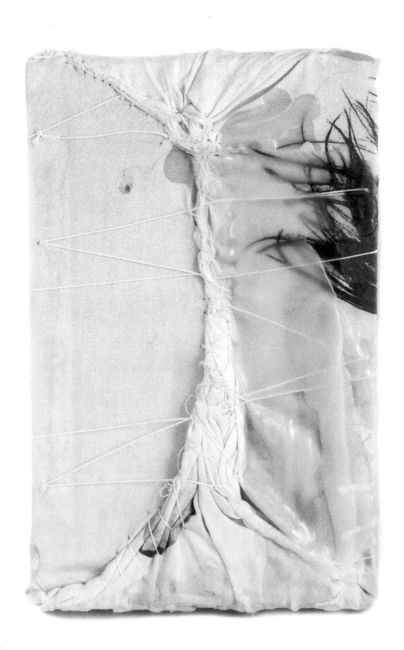

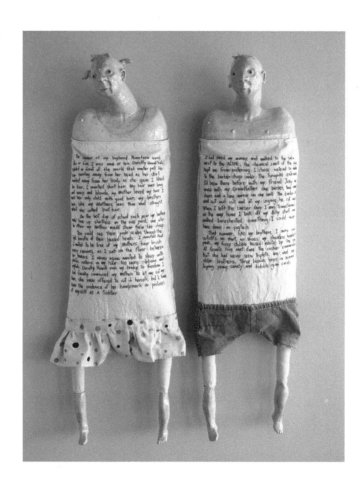

Suzanne M Long, *The Summer of My Boyhood,* Clay/Fabric, 31 x 21 x 6, 2010
www.suzannelongart.com

The summer of my boyhood. Nineteen seventy-three or four, I was nine or ten, Dorothy Hamill had skated in front of the world that winter past. Her hair twirling away from her head as her skirt twirled away from her body as she spun. I liked her hair, I wanted short hair. My hair was long and wavy and blonde, my Mother loved my hair. I was her only child with good hair, my brothers' hair like my mothers was thin and straight what she called bad hair. On the last day of school each year my brothers' would line up shirtless on the side yard, One after the other my Mother would shear them like sheep.

You could see their pink scalps through the light bristle of their buzzed heads. I wanted that. I wanted to be free of my mothers' hair brush every evening, as I sat on the floor between her knees. I never again wanted to sleep with plastic rollers in my hair. No more ribbons and pig tails. Dorothy Hamill was my bridge to freedom, I had finally convinced my Mother to let me get my hair cut, she ever offered to cut it herself, but I had seen the evidence of her handy work in pictures of myself as a toddler.

I saved my money and walked to the salon next to the ACME, the chemical smell of the place kept me from entering. I choose instead to walk to the Barber Shop under the turnpike entrance, I'd been there before with my friend Joey and once with my Grandfather. One barber, two swivel chairs and a long mirror. He cut and cut and at my urging he cut more. When I left the barber shop I was transformed, on the way home I took off my itchy shirt and walked bare-chested, something I could never have done in pigtails.

That summer, like my brothers I wore only cutoffs, no shirt, no shoes, my shoulders hopelessly pink, my fuzzy stubble kissed white by the sun.

At Grants the cashier commented that she had never seen triplets, me my brother's Kenny and Jeffrey, three blond boys in summer clothes, buying penny candy and bubble gum cards.

Sharon Paster
The Journey Defines the Artist

Tell us about yourself

My grandfather painted in his basement, so I fell in love with the smell of oil and turpentine at a young age. I painted in college, then I stopped for many years (for many reasons: frustration, wanting to earn a living, having a family). I went back to it in earnest about 20 years ago, making up for lost time, taking classes, falling in love with the materials, finding representation and a wonderful community to support my habit.

Who are your biggest influences?

Chester Arnold was one of the most influential painting teachers I ever had. I love the work of William Kentridge and Cy Twombly, and Van Gogh and Rembrandt among the classics. Today I am smitten by the work of Chantal Joffe, Rob Szot, Amy Ellingson, Edwidge Fouvry and Michael Hedges.

How do you find new opportunities?

I'm sorry to say that I haven't been good about applying to that many shows or residencies. I've been learning more about social media through my colleagues and trying to put my work out there without too much fear. But I don't think it has really helped much career-wise. I have a few galleries and am happy to say that the relationships have been pretty successful.

What do you do to stay motivated?

My studio is at the ICB Sausalito, which is filled with over 100 artists on the waterfront in Marin County. Being in the community, surrounded by so many creative people and learning opportunities, is a huge motivator. Just looking at the beauty out my studio window is another source of inspiration.

if you could tell your younger self something, what would it be?

It took me years to say that I am an artist, even after making art for a long time. I kept waiting to achieve a certain level of output, mastery and recognition. If I had been working around more artists, maybe I would have been quicker to say that the journey defines the artist, not necessarily reaching a destination--which is what I was waiting for.

What is your work focusing on now?

I am still interested in exploring spatial mystery: the relationships and movement between things, contrasting the fixed with the fluid. I am also fascinated by people, and trying to see how I can work the figure into more of my art practice. So far, it's not really working!

Laura Sanders
Exploring Identities

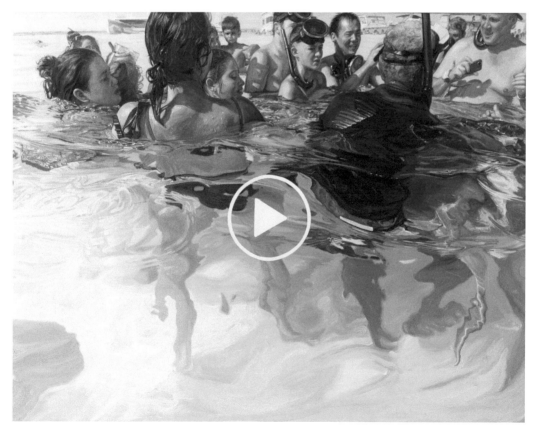

All Inclusive, 40 x 52, oil on canvas, 2019

Tell us about yourself

I am an Ohio artist. I went to art school at the Columbus College of Art and Design. After graduating I began my career as a Scenic Artist for regional theatre companies. Although I enjoyed this work, my goal was always to be a full time studio artist. For the past 15 years I have been able to achieve this goal!

Who are your biggest influences?

As a young artist, Eric Fischl, Lucian Freud, and Wayne Theibaud, were a few painters that were very important to me. Recently I had had enough of only seeing paintings online, so I took an impromptu trip to NYC to see work by a couple of my current crushes, Lois Dodd and Neil Welliver.

What kind of opportunities do you look for and how do you find them?

I would love to connect with curators and have the opportunity to join thematic group shows. I think it is a great opportunity to meet other artists, and see a collection of work in greater context through the lens of the curator.

What do you do to stay motivated?

I have to remember to take breaks! Just getting out once a day to go for a walk keeps the creative juices flowing.

if you could tell your 20-something self something, what would it be?

I would tell myself to stop doubting and get to work!

What is your work focusing on now?

I am thinking about the irony of using women as personifications of Nature, as they have been throughout art history, when in reality we are advised to go nowhere by ourselves, let alone the woods! This is leading me to explore the use of art historical references in the subject matter of my paintings.

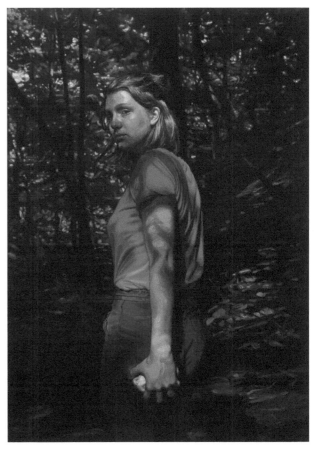

By Herself:Glen Echo, oil on canvas, 2019

Gina Tuzzi
Gathers Strength From Destructive Goddesses

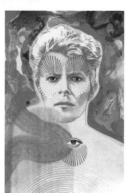

Untitled (Bowie) acrylic on paper, 2017

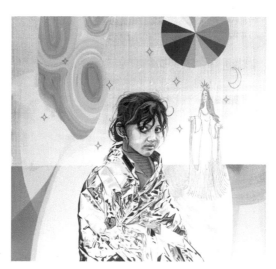

La Diosa Del Mar, acrylic on panel, 36x36, 2017

By Jennifer Lynne Roberts

I first encountered Gina Tuzzi's work through Jen Tough Gallery during a group show, *Guilty Pleasures*, in 2017, and again later at *New Lands*, a pop up exhibit Tough held in the Dogpatch, San Francisco. Both exhibits teased pieces for her upcoming solo show, *Pele and The Sensual World*, at the Jen Tough Gallery. It was Tuzzi's solo show where I'd come back to one painting again and again: *They Say That I Don't Mourn Because They Don't See Me Cry (La Luna Para La Llorona)*. La Llorona refers to a woman cursed to eternally wander and weep, looking for the children she murdered. La Luna Para La Llorona now hangs on my wall.

Tuzzi works in oil, acrylic, and mixed media to create vibrant, delicious deity pop art on paper and wood panels ranging in size from 26" x 36" to two 58"x 36" panel paintings of Tina Turner that, apropos of the diva, dominates the room.

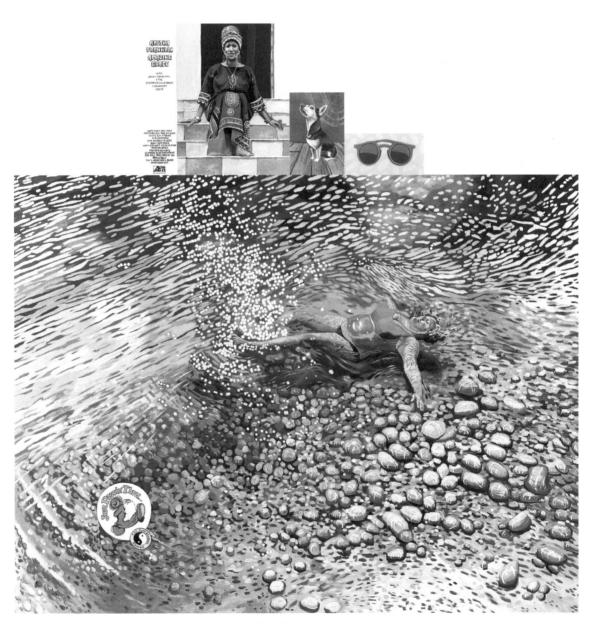

The Time Traveler, 48"x48", acrylic and oil on panel, 2020 (self portrait) | www.GinaTuzzi.com

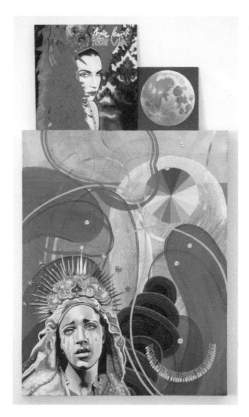

*They Say That I Don't Mourn Because They Don't See Me Cry
(La Luna Para La Llorona)* Acrylic & oil on panel,
triptych / 48x32, 2018

Tuzzi's mouth-watering, taffy-colored palette draws you to her work, a mystical pull toward the goddesses and women dominating each canvas. Coupled with album cover references, it's a confectionary treat for the senses, evoking nostalgia without sentimentality. Part of what keeps Tuzzi's work grounded is the elements she includes—birds of prey, archetypical goddesses, weeping women, divas—and the subject matter she paints. Tuzzi incorporates Christian folklore, spiritual, pop, and women's culture to address how it feels to be a woman in today's world. Her work is autobiographical and historical, highlighting an ancestral lineage of a communal female experience.

"I considered the moments where bursts of emotionality were pacified, suppressed or tampered down gracefully as a sacrifice of emotional labor for someone else's benefit. I imagined these collective feelings welling up inside, pressurizing and boiling deep within us, not unlike a dormant volcano"
—Gina Tuzzi

An admitted audiophile, Tuzzi uses music as further inspiration, both visually and devotionally, by replicating album covers and placing them atop some of her paintings like altarpieces or prayer cards. Her paintings include text and lyrics that one could read as indulgences: repeat them for remission of the temporal punishment in purgatory that these "destructive" women inevitably suffer.

Tuzzi's work allows for the reclamation of female power. It allows you to own the wholeness of womanhood without apology. From the declaration of "I regret my life won't be long enough to make love to all the men I'd like to," to "Patti Smith's "she is sublimation," Tuzzi tells us to cheer up, sisters, and rise resurrected.

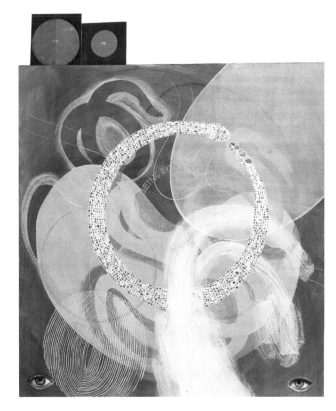

Nature Without Man, oil and acrylic on panels (triptych) 2017

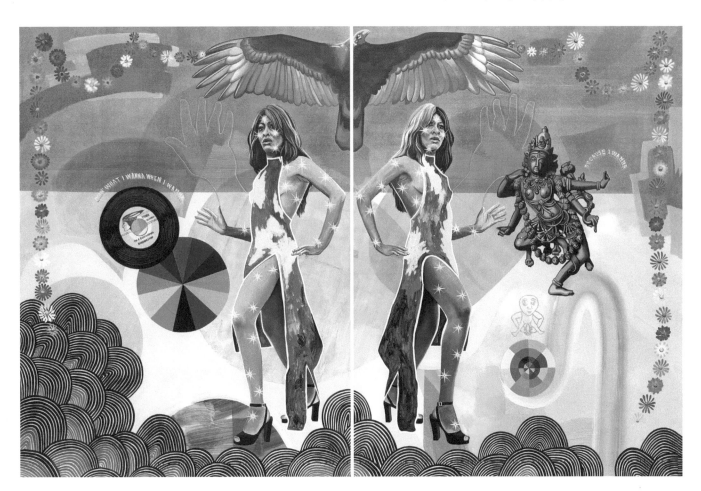

Now Do Your Thing, Star Sister, Acrylic & oil on panel, diptych / 36 x 48 (x2) 2017-2018

Diane Williams and Chuck Potter both hold Master of Fine Arts degrees in Studio Art and Consciousness studies from John F Kennedy University in Berkeley, California. Additionally, both have studied at the University of Hangzhou China, incorporating calligraphy, traditional Chinese landscape painting and Chinese medicine with their western art practices. Recently, they took part in a two-week workshop in Skopelos, Greece. They have studios in Benicia, CA. (I AN I Studio) and Greenville, CA. (Diamond I AN I Studio). Diane and Chuck have conducted workshops locally and statewide for the past 15 years, exhibited extensively, and have won numerous awards for their artwork.

Diane Williams + Chuck Potter
Artists as Teachers + Partners

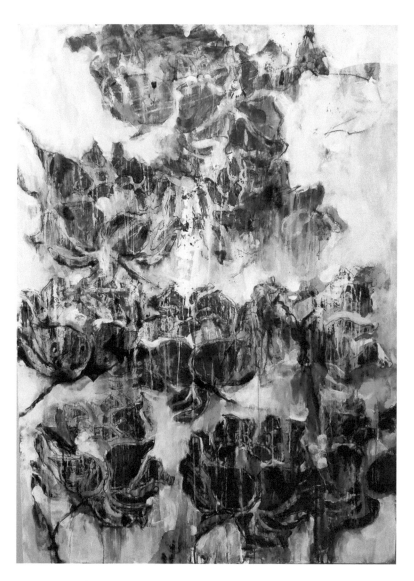

Images

This Page: Diane Williams, *Purple Hydrangeas* 48 x 60 in acrylic, rust and Stabilo pencil on canvas, 2018

Right Page: Chuck Potter, *Ghost Dance*, mixed media on canvas, 48in x 60, 2019

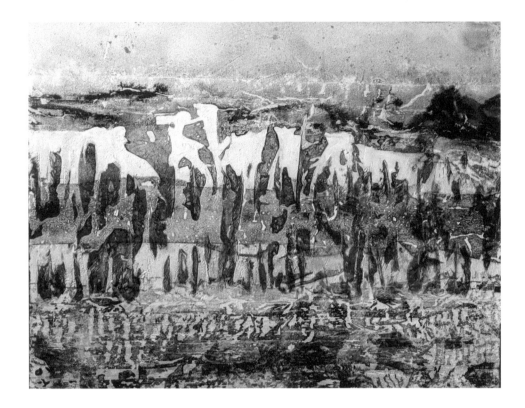

How do you manage teaching together? Sharing a studio, raising 5 children, and obtaining our MFA's together, provided a natural formation of teamwork. We share common goals and different perspectives encouraging students to find their own authentic voice in their artwork. What excites us both in this method are the unique and surprising responses of our students discovering their creative spirit. In short, we love teaching.

What helped you decide to start teaching? While living in an artist's community and returning back to school we realized the importance of sharing our education and experience with others. There are many benefits working with other artists in a nurturing and supportive forum. Teaching on a regular basis provides a steady creative interaction. We realized that many of our students were feeling lost, confused about what's next, and were looking for something to give them direction and purpose. Artmaking provides a vehicle for people to reconnect with others and find their authentic voice.

What do you see as the benefits of teaching? We learn as much as we teach during art workshops. It is a reciprocal process in sharing methods and ideas. A big challenge is instructing students on how to see art. Our intuitive painting workshops give students, who are looking for a deeper sense of who they are at this stage in their lives, the tools and techniques they need to appreciate their ability to create and see art.

How did you know when you were ready to teach? One of the benefits of obtaining a MFA degree is that it prepares you teach art. We also learn by taking and participating in workshops. We have learned from other instructors and or own first-hand experience being students ourselves. Just like artmaking, teaching is a constant pursuit of improvement.

How did you start? We began teaching out of graduation by being adjunct professors for National University and Diane taught at Chabot College. From there, we started teaching at Concord adult education and then directly from our studio for many years. After building a steady following we broadened our workshop offerings regionally.

Can you share your best teaching advice to other artists?
Develop a consistent and serious studio practice
Build your resume
Seek education
Start locally and build a following

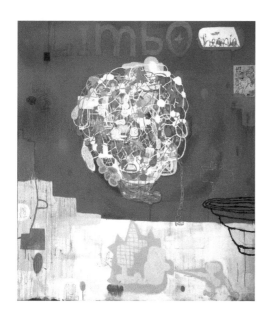

John Yoyogi Fortes
Born in a Taxi in Tokyo

Tell us about yourself:

I'm a Filipino-American painter living in Sacramento, CA. I was born in a taxi on Yoyogi Street in Tokyo, Japan, hence my middle name. As an Army brat we I lived in California and Arizona. My earliest recollection of drawing was at Hunters Point in San Francisco when I was in kindergarten and first grade. The majority of my youth though was spent in the Central Valley around Lathrop. Drawing as a kid was a way to pass the time and be in my head. While I was at San Joaquin Delta College in Stockton I had my first encounter with a career artist from NY. He really affected the way I viewed art at the time and sent me on a search to find out what art really was. After doing a stint in the Air Force I attended Fresno State University as a Fine Arts Major.

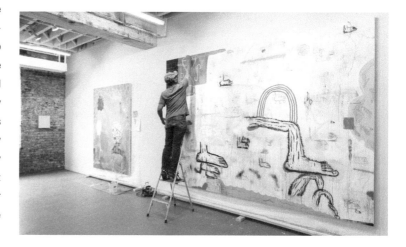

Who were your biggest influnces? At Fresno State University I studied under artists, Terry Allen and Charles Gaines. Both of them changed the way I viewed my surroundings, challenged my thinking, and made me question myself. To this day, what I learned from Terry Allen is a big part of who I am as an artist and my work.

I've always been a sponge so there are so many artists who I have gravitated to. Aside from artists I'm also interested by graphic arts, illustration, folk art, graffiti, advertising globally, kitsch, decay, etc. A few artists who I looked at in terms of referencing culture in their work were Fritz Scholder, Enrique Chegoya, Manuel Ocampo and Santiago Bose.

How do you stay motivated? I do my best to remain curious about what I am doing, see as many shows within and outside of Northern California, do studio visits and try not to be isolated. Sales don't drive me. I make things for myself.

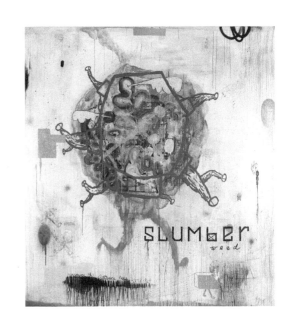

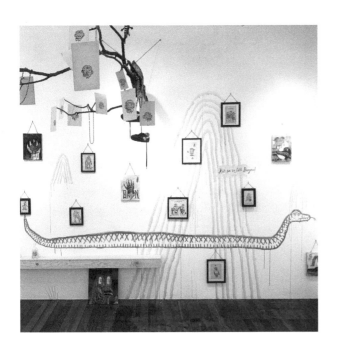

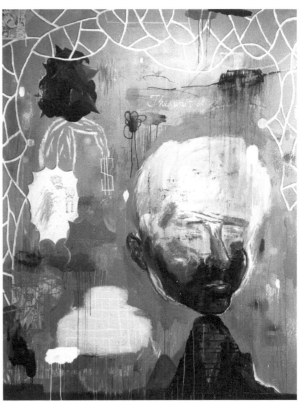

What kind of opportunities do you look for? Lately I haven't actively been looking for exhibition opportunities, but focusing on getting a few more residencies and concentrating on my practice. Since I've attended two residencies, I've made some great connections with other artists, curators, and individuals within arts organizations that had I not been at a residency I would still be somewhat isolated. Most of the shows I've participated in have been through invitation, an artist call or a referral from another artist.

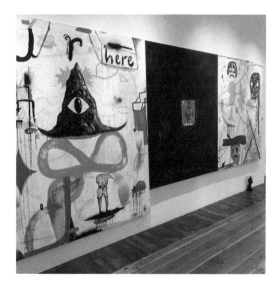

What would you tell your younger self? Take everything with a grain of salt. Don't isolate yourself. Apply to residencies. Don't always reject what may not make sense to you visually. Not everything you make is that good. Don't follow, but be inspired and create your own path!

What is your work focusing on now? When I was at the Bemis Center for Contemporary Arts I was wanting to explore making work that wasn't a painted rectangle on a wall. I'm now looking at other materials that are even sculptural, other ways of hanging the work and installing the work and sculptural pieces in an installation that relates to the work and possibly a narrative. My work still revolves around self, identity, navigating spaces and assimilation.

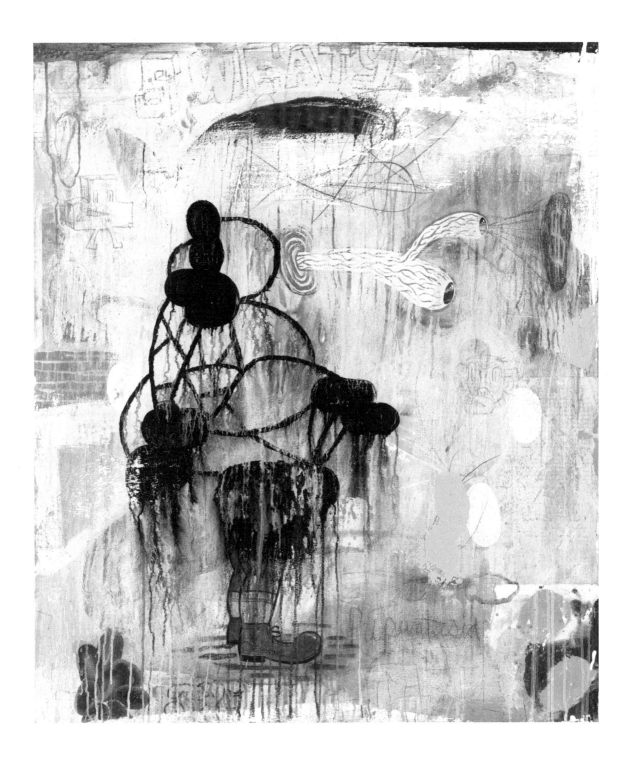

PHOTOS

First spread: left page: *Limbohemia,* 2017, mixed media on canvas, 72" x 68"
Middle: John working at Bemis Center for Contemporary Art during his residency, photo by Colin Conces

First spread: right page:

Slumberweed, 2016, mixed media on canvas, 72" X 66"
The Wait of Fear, 2018, mixed media on canvas, 72" X 66"
2019 Solo exhibition install at Jen Tough Gallery, Kit pa ça lé Bayou! / "Don't let it pass/go Bayou!"

Second spread: left page:
Top: John working at Bemis, photo by Colin Conces
2019 Solo exhibition at Jen Tough Gallery, Kit pa ça lé Bayou! / "Don't let it pass/go Bayou!"
Untitled 2, ink, graphite, mixed media on paper, 2019

Second spread: right page:
Sweaty Pickle, oil, acrylic and mixed media on canvas, 42" X 36, 2016 (prints available)

Kate Kretz
Beautiful Gut Punch

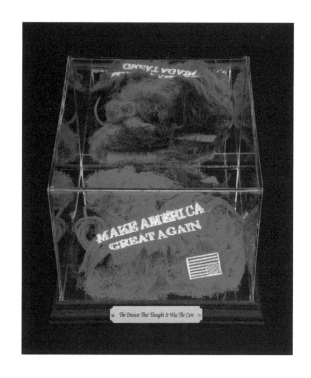

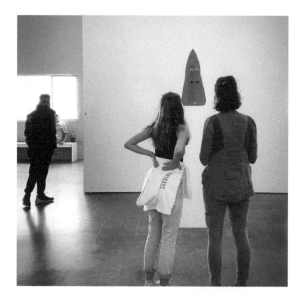

This page, top to bottom:

Hate Hat II, Dismantled:
The Disease That Thought It Was The Cure
2019, unravelled MAGA hat (ripped apart thread by thread),
baseball cap display case (mirrors, plexiglass, wood), en-
graved brass plate, 8 x 9 x 8.5", 2017

View from Kate's solo exhibition, San Francisco, 2019

Eminent Domain For Unwilling Vessels
2019, deconstructed MAGA hats reconstructed
as Handmaid's bonnet. 13" x 9" x 8"

Right:
Hate Hat
Deconstructed MAGA hats, cotton, thread,
28 x 9 x 12", Edition of 3 with an Artist Proof, 2019
Hate Hat 1, Manuel De Santaren collection

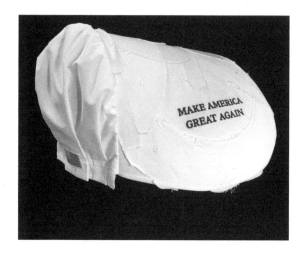

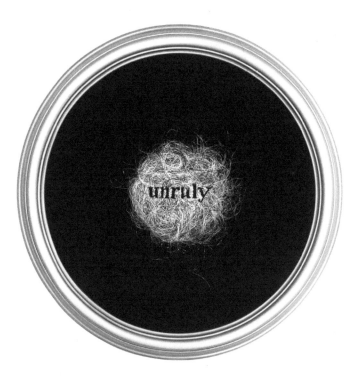

"I make art to keep myself sane. It is a way to process what is happening in the world around me, and I do it compulsively. My heart and nervous system resemble that of a folk artist, albeit one who has read way too many books.

I often experience news stories of inhumanity as a literal blow to my body, and carry the negative energy around with me until I process a way to exorcise it from my person, through transformative creation. I make the objects that need to exist in the world to represent some essential truth: it is undeniably clear what needs to be manifested through me at any given historical moment. While in-process, my work functions as a meditation, a healing prayer, a potent incantation to embed the finished object with as much power as possible. Often, the concentrated energy embued in the object ultimately manifests as a scream, appropriately rivaling the impact of that original negative impetus that demanded its materialization. I aim for a beautiful, exquisitely-crafted gut punch.

I consider the inordinate amount of time invested in each piece as a gift given to the viewer, and stop only when there's not one more thing I could do to make it more powerful. In this day and age, it often feels as though the earnest, cathectic things I make are an act of profound resistance: I give birth to the tactile as I am swallowed by the virtual. I obsess over craft as our world becomes disposable. I wield emotion in its messiness because it's uncool. I work until my hands shake, because the world does not care. I am banging my head against the wall, but the stain is beautiful."

www.KateKretz.com

Unruly, 2013, embroidery on human hair, velvet, convex glass, frame, 3 x 3", 12 x 12" framed

Hag, 2013, embroidery on human hair, velvet, convex glass, frame, 3 x 3", 14 x 14" exterior frame dimensions.

Feral, human hair embroidery on hair, velvet, convex glass, frame, 3" x 3", 11" x 11" framed

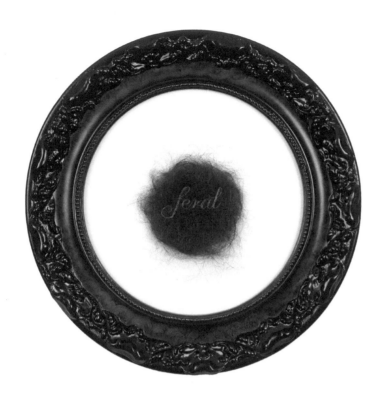

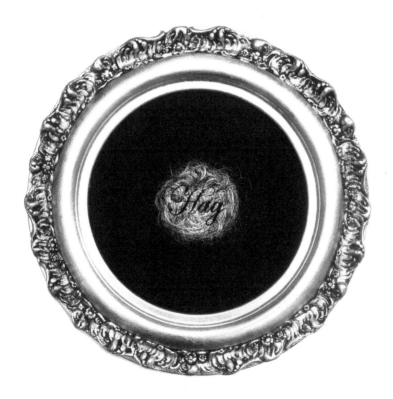

Pável Acevedo
Honoring Culture

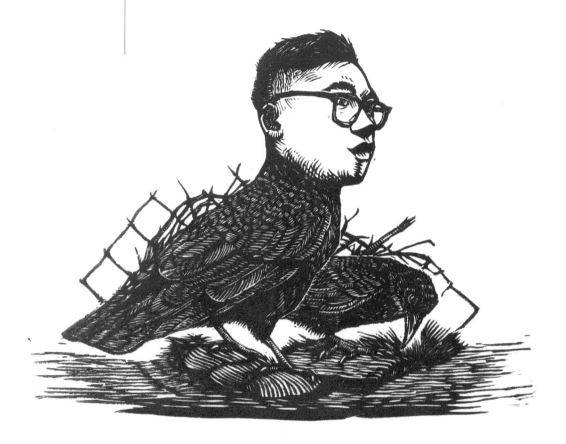

"The images that are first carved on a linoleum or wood plate and later printed on paper or painted on a wall are the result of a learning process that began in the printmaking workshops/talleres in Oaxaca city. My education was primarily in traditional techniques like lithography, woodcarving and drawing; in this period of time I found the portrait as subject for me to communicate with others.

In 2010 I left Oaxaca and I moved to California. My artwork then took the relief print as a way to talk about my new home and life in the US and has also been a way to find myself in this country. Through the representation of my surroundings, the portrait was both challenge and an appeal to me. The portrait turned into a portal where I can tell stories and try to find my language as an artist. Every portrait that I have carved or drawn has picked up stories of struggle, hope, highways, cities, animals, houses, protest, signs, injustice, malls, or even pre-hispanic glyphs. The power to exist between two cultures was no longer my goal; my purpose was now to create a third world, with other possibilities within my images and production. These images serve as a reminder of where I come from and to pay homage to culture and tradition, in a contemporary way. I let the faces inhabit new stories of struggle and perseverance, which exist among many others that have to be told."

Above: *We're Taking Over (study),* linocut print on paper, 2019
Right: *Word of Mouth,* linocut print on paper, 2020

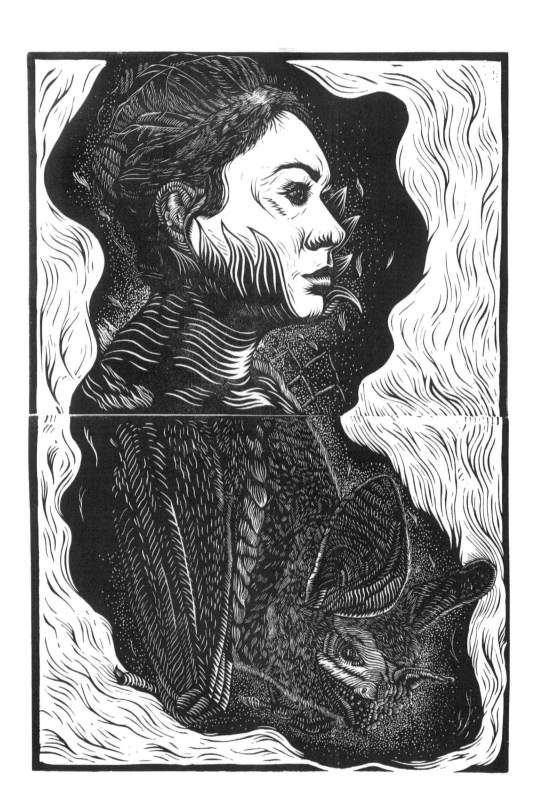

Erin McCluskey Wheeler
Things Unsaid

"I make bright colored collage works that employ a meticulous assemblage of found papers often bound together with looping brushstrokes. With both an abstract and graphic style, my art is sometimes symbolic or whimsical, and plays with ideas of nostalgia and visual memories in a narrative context. I source both found materials and create my own painted paper collage material to create densely layered paintings full of light and space."

These two works, *Things Unsaid 1* and *Things Unsaid 2,* were made when Erin was dealing with not one, but both parents in hospice. These works addressed her new identity and role as caretaker for her parents.

Erin has BA in studio art, and a BA in art history from Beloit College, and an MFA in writing from California College of the Arts. She lives and works in the Bay Area of California.

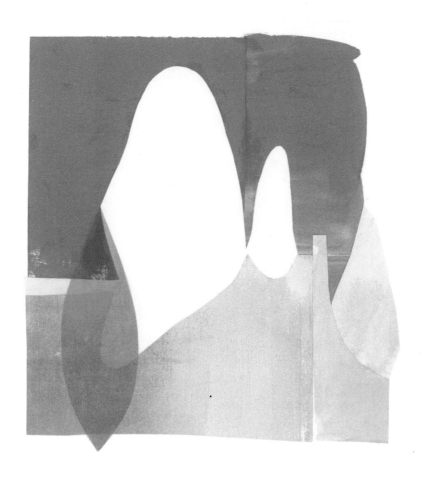

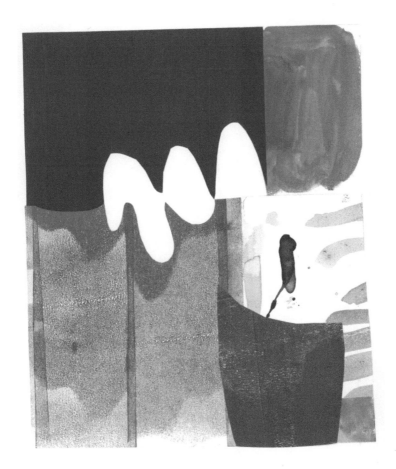

www.JenTough.gallery